# LOVE IS A

# PUP

summersdale

LOVE IS A PUP

An Hachette UK Company
www.hachette.co.uk

Summersdale Publishers Ltd
Part of Octopus Publishing Group Limited
Carmelite House
50 Victoria Embankment
LONDON
EC4Y 0DZ
UK

www.summersdale.com

Printed and bound in China

ISBN: 978-1-78783-261-9

Substantial discounts on bulk quantities of Summersdale books are available to corporations, professional associations and other organizations. For details contact general enquiries: telephone: +44 (0) 1243 771107 or email: enquiries@summersdale.com.

# ♥ INTRODUCTION ♥

What's better than a puppy? Lots of puppies! They may have little paws, but they have big dreams, and the pups in this book are bound to melt your heart. Their ears are too big for them, they have more fluff than seems possible, and don't even get us started on those adorable puppy-dog eyes. That's why we love them. So dive in for a celebration of all kinds of pooches at their most tiny and cute, and see why dogs give us oh so many reasons to adore them.

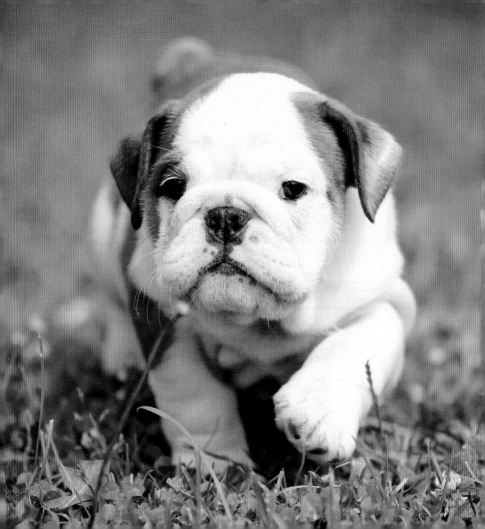

ALWAYS BE
♥ PUP-PARED ♥

FOR CUTENESS!

# DOGS ARE NOT OUR WHOLE LIFE, BUT THEY MAKE OUR LIVES WHOLE.

Roger Caras

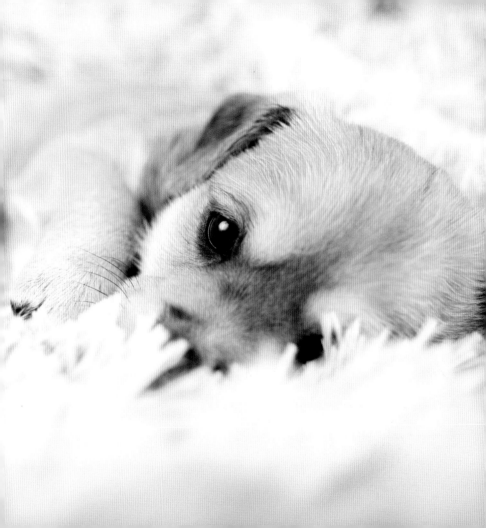

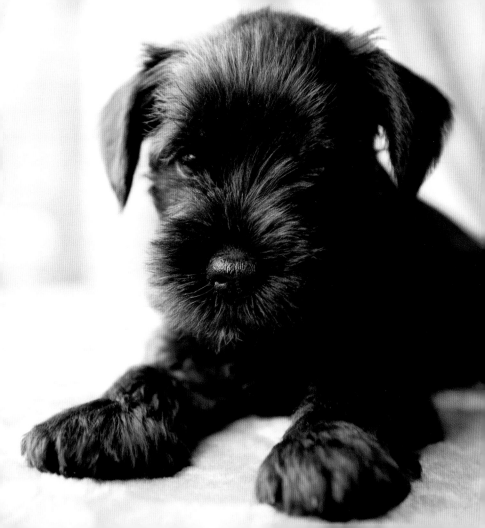

MY MOUSTACHE

BRINGS ALL

♥ THE PUPS TO ♥

THE YARD

# WHEN YOU FEEL LOUSY, PUPPY THERAPY IS INDICATED.

Sara Paretsky

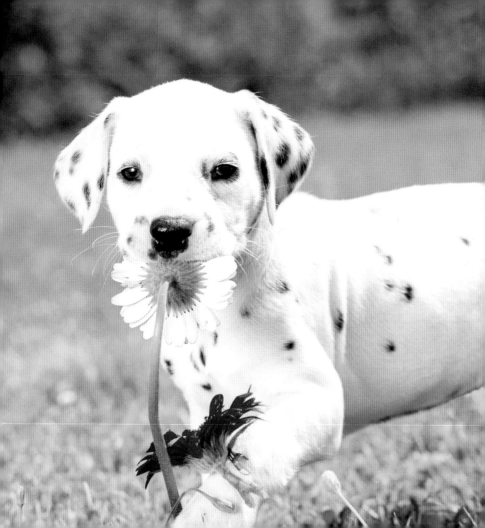

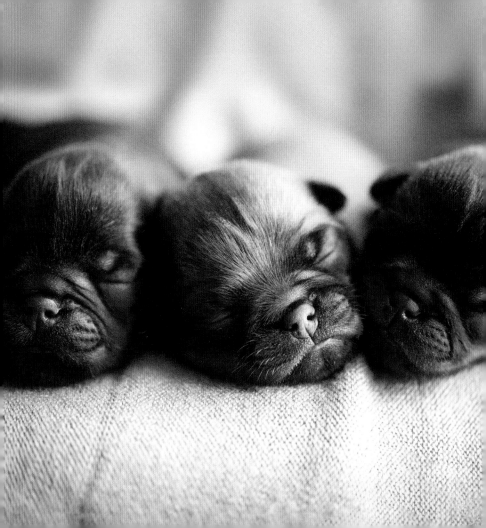

ALL YOU NEED
IS LOVE...
♥ AND A PUP ♥
OR THREE

# I AM I BECAUSE MY LITTLE DOG KNOWS ME.

Gertrude Stein

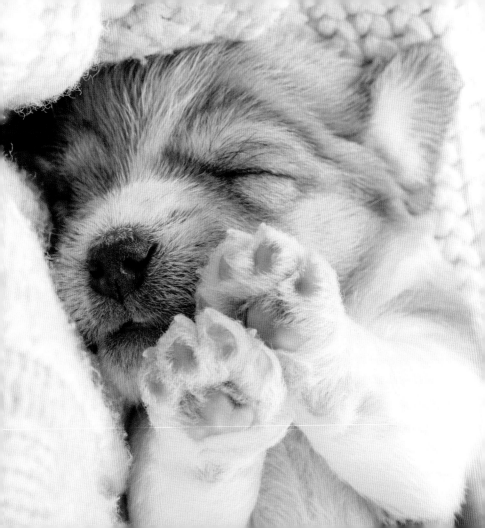

I MAY BE LITTLE,
BUT MY LOVE
♥ FOR YOU ♥
IS HUGE!

# THE DOG WAS CREATED SPECIALLY FOR CHILDREN. HE IS THE GOD OF FROLIC.

Henry Ward Beecher

♥ THE SILKY LIFE ♥
_____

CHOSE ME

# PUPPIES ARE GOD'S IDEA OF A PERFECT WORKOUT PROGRAMME.

Stephen King

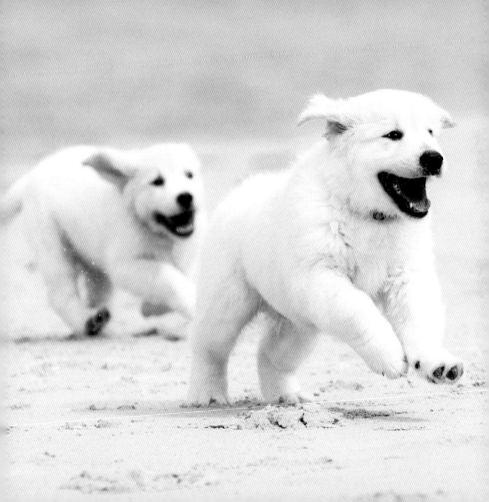

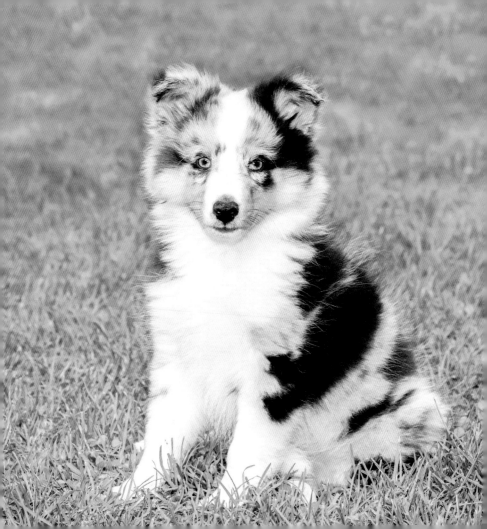

♥ I WOKE PUP ♥

LIKE THIS

# A PUPPY IS BUT A DOG, PLUS HIGH SPIRITS, AND MINUS COMMON SENSE.

Agnes Repplier

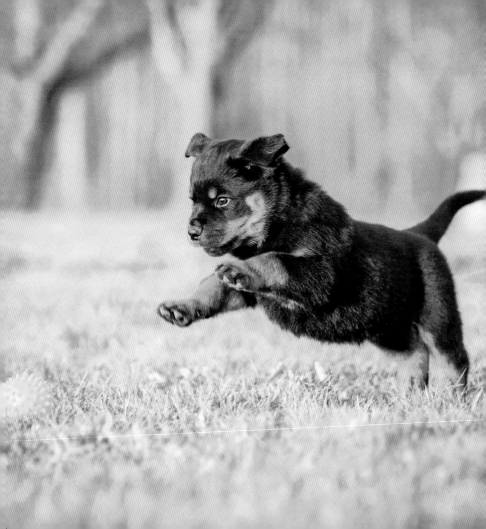

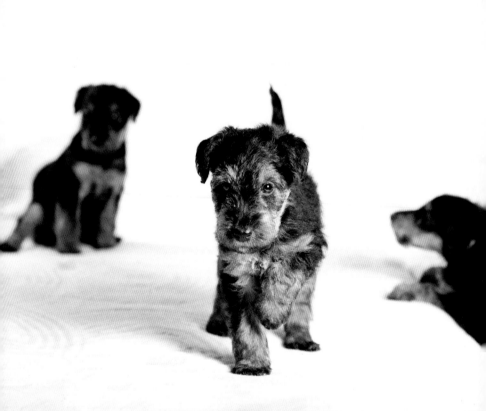

# #SQUAD
## GOALS

# A DOG IS A BUNDLE OF PURE LOVE, GIFT-WRAPPED IN FUR.

Andrea Lochen

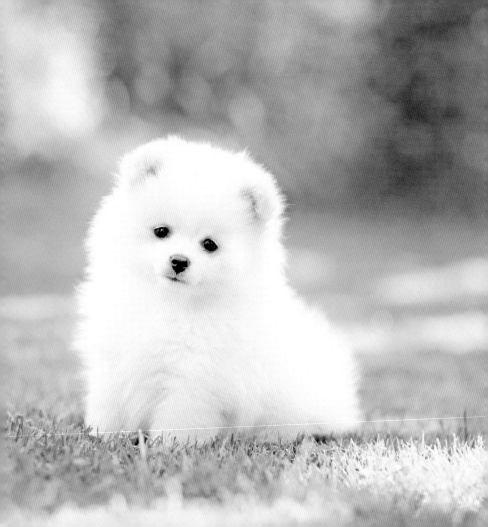

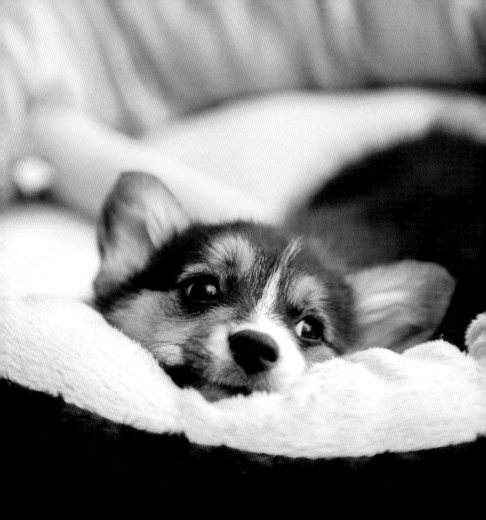

THE BEST
CURE FOR A
♥ RUFF DAY? ♥

NAP TIME!

# SOMETIMES THE BEST THING THAT CAN HAPPEN TO A PERSON IS TO HAVE A PUPPY LICK YOUR FACE.

Joan Bauer

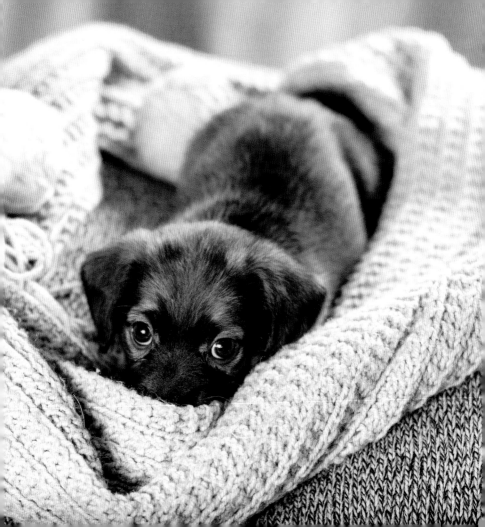

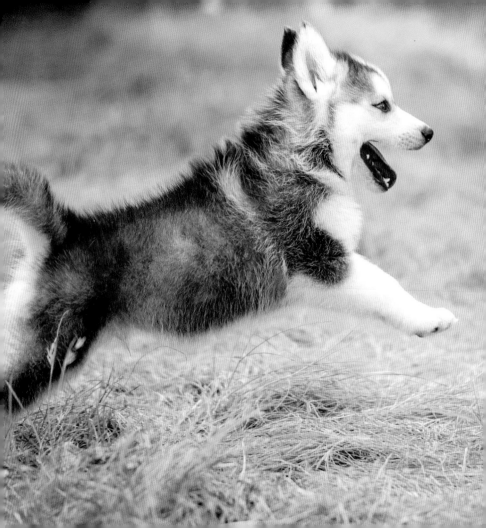

I AM A
NINJA WARRIOR.
❤ AAAAAND... ❤

POUNCE!

THE GREAT PLEASURE OF A DOG IS
THAT YOU MAY MAKE A FOOL OF
YOURSELF WITH HIM AND NOT ONLY
WILL HE NOT SCOLD YOU, BUT HE
WILL MAKE A FOOL OF HIMSELF TOO.

Samuel Butler

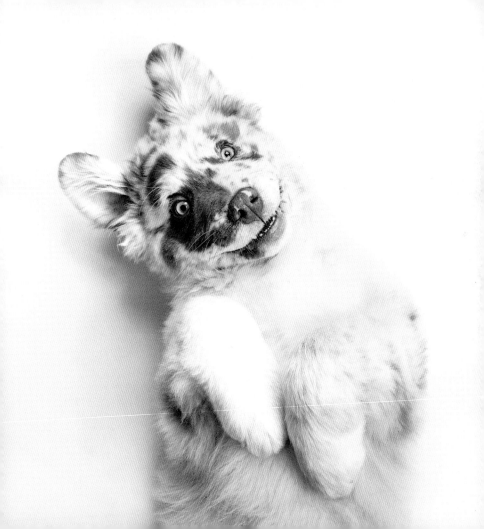

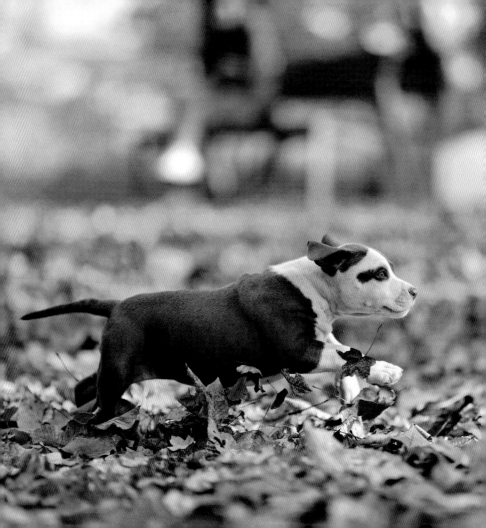

CUTENESS? I CAN ❤ FETCH THAT ❤

FOR YOU!

# "I'M NOT ALONE," SAID THE BOY. "I'VE GOT A PUPPY."

Jane Thayer

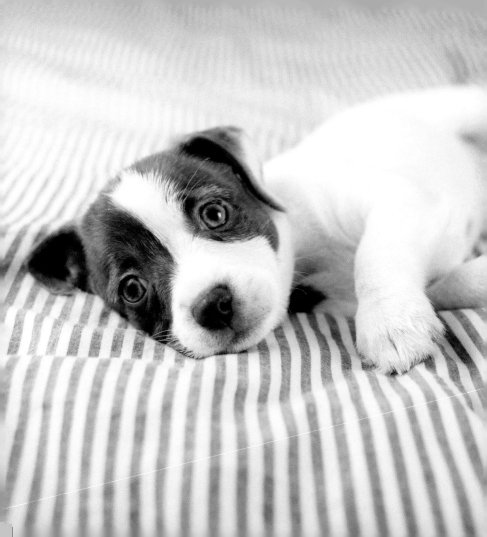

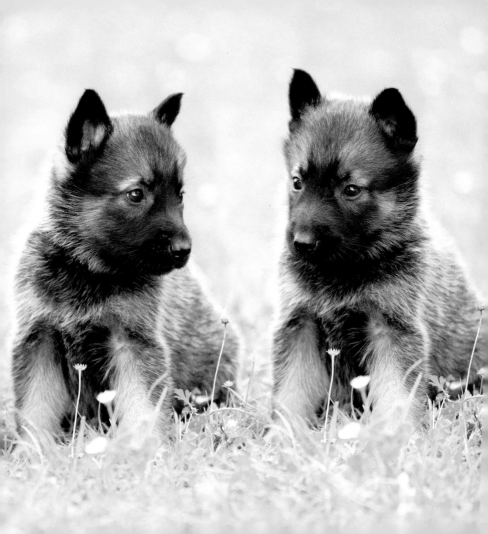

YOU ARE

♥ PAW-FECT ♥

TO ME

# IT'S IMPOSSIBLE TO KEEP A STRAIGHT FACE IN THE PRESENCE OF ONE OR MORE PUPPIES.

Anonymous

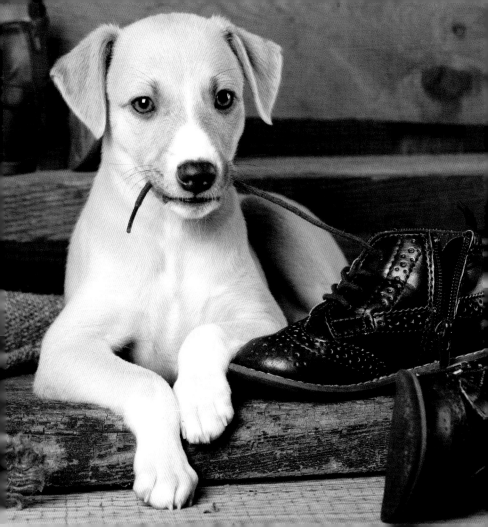

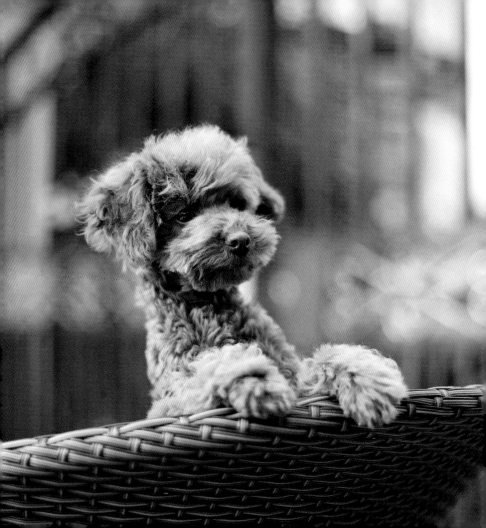

DID SOMEBODY

♥ SAY ♥

SAUSAGES?!

# HAPPINESS IS A WARM PUPPY.

Charles M. Schulz

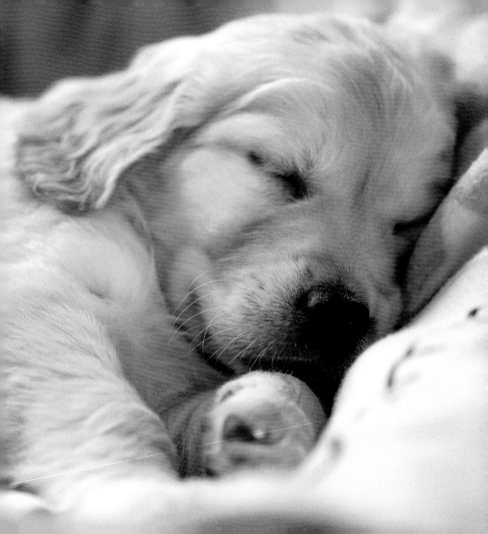

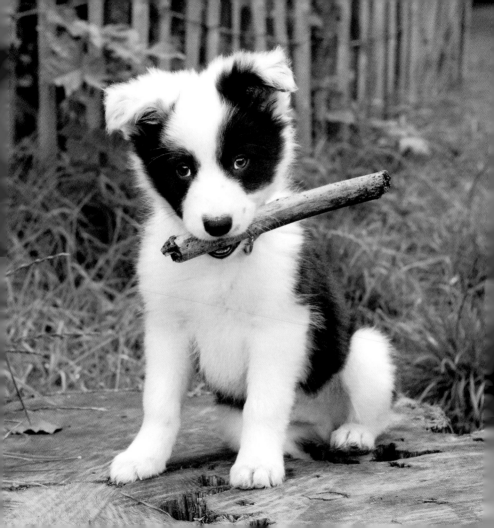

IF YOU WANT THE
STICK SO MUCH,
WHY DO YOU KEEP
♥ THROWING ♥
_____
IT AWAY?

YOU THINK DOGS WILL NOT BE IN
HEAVEN? I TELL YOU, THEY WILL
BE LONG BEFORE ANY OF US.

Robert Louis Stevenson

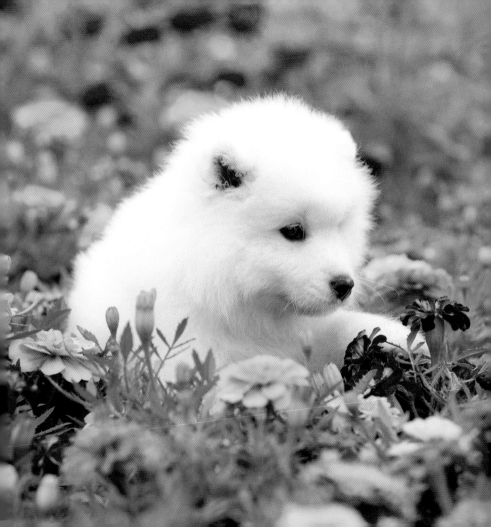

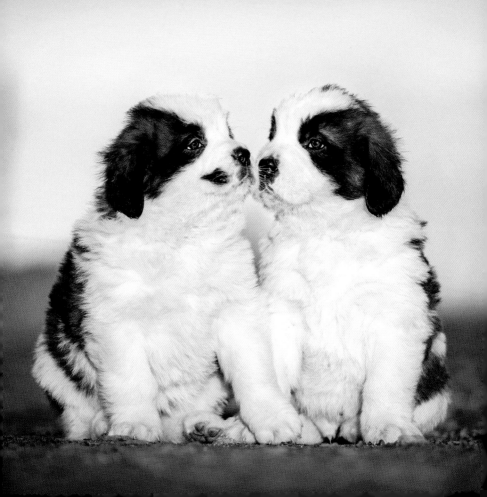

I THINK
THIS IS WHAT
♥ THEY CALL ♥

PUPPY LOVE

# THOUGH SHE BE BUT LITTLE, SHE IS FIERCE.

William Shakespeare

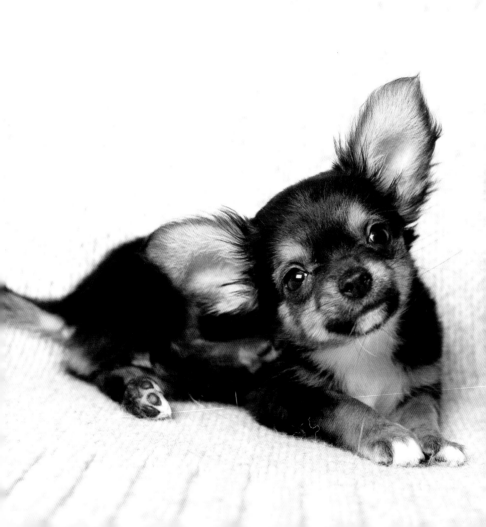

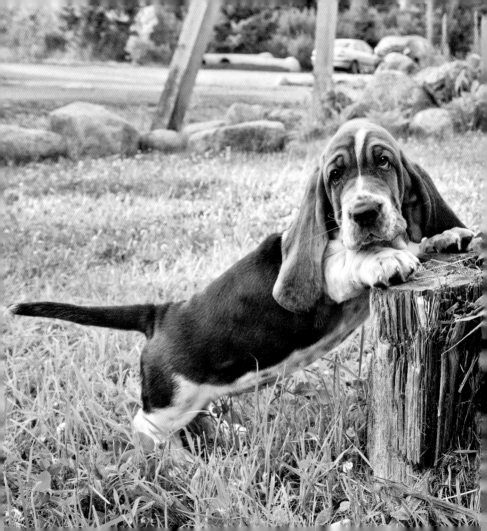

SILENCE IS GOLDEN.
UNLESS YOU HAVE
A PUPPY — THEN
♥ IT'S JUST ♥
SUSPICIOUS

# WHY DOES WATCHING A DOG BE A DOG FILL ONE WITH HAPPINESS?

Jonathan Safran Foer

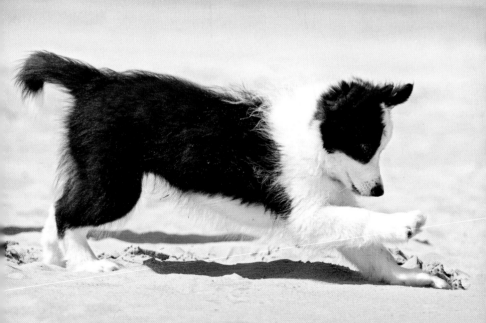

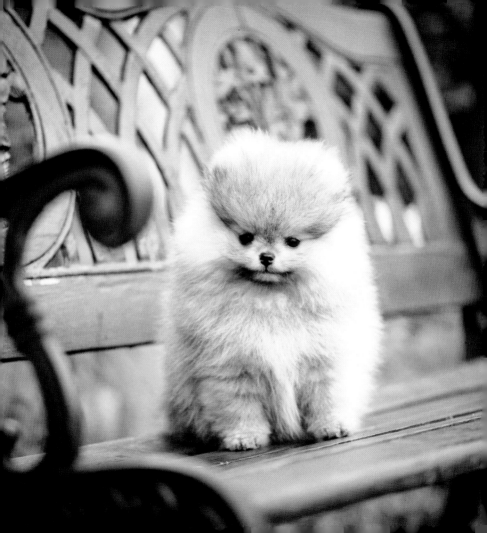

I'M FLUFFY

♥ AND I ♥

KNOW IT

PUPPIES ARE NATURE'S REMEDY
FOR FEELING UNLOVED... PLUS
NUMEROUS OTHER AILMENTS OF LIFE.

Richard Allen Palm

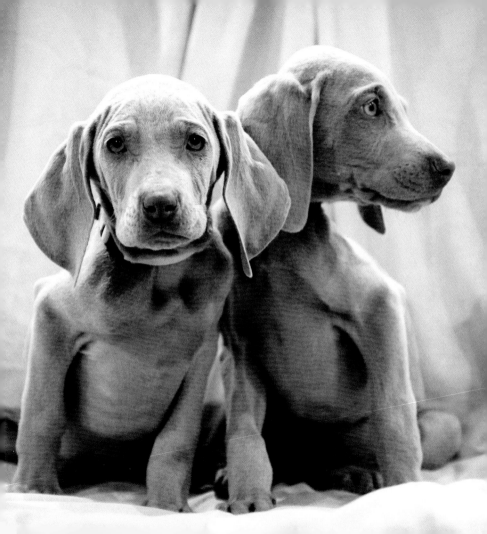

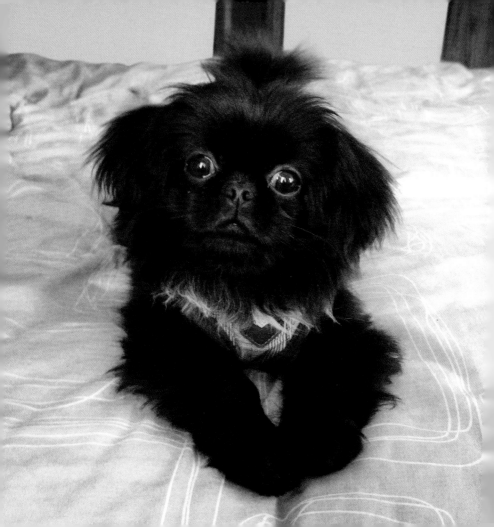

I WONDER HOW

❤ MANY LIKES ❤

THIS'LL GET?

THE GIFT WHICH I AM SENDING
YOU IS CALLED A DOG, AND IS
IN FACT THE MOST PRECIOUS AND
VALUABLE POSSESSION OF MANKIND.

Theodorus Gaza

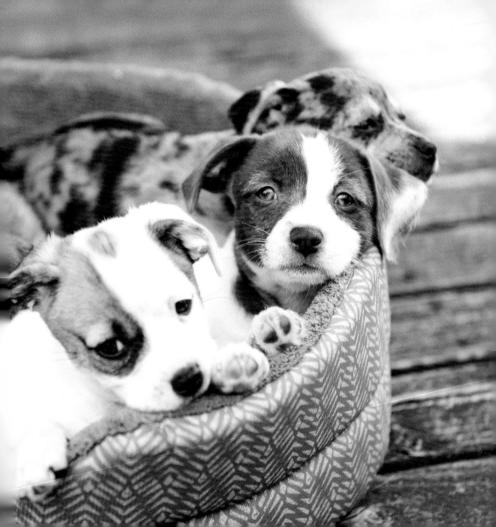

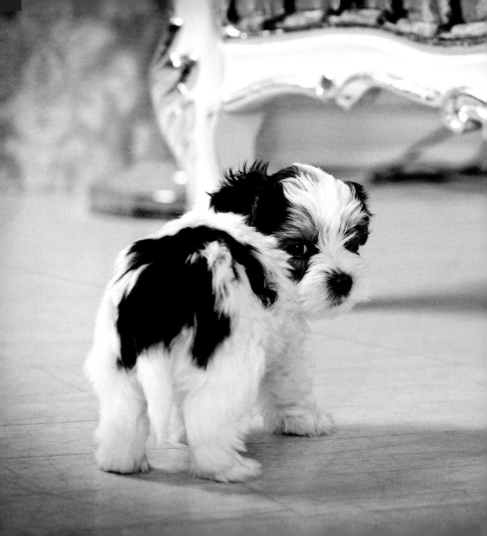

TO BOLDLY
GO WHERE
♥ NO PUP HAS ♥

GONE BEFORE

# THE AVERAGE DOG IS A NICER PERSON THAN THE AVERAGE PERSON.

Andy Rooney

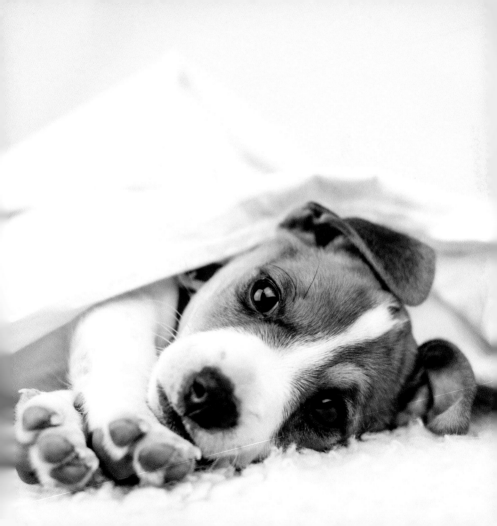

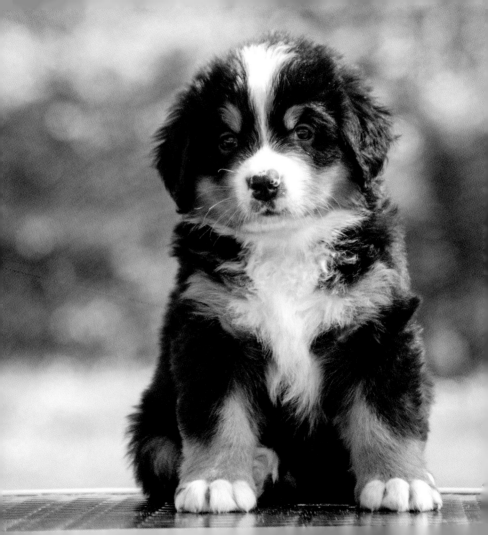

# HOME IS
## ♥ WHERE YOUR ♥
## PUPPY IS

# THERE IS NO PSYCHIATRIST IN THE WORLD LIKE A PUPPY LICKING YOUR FACE.

Bernard Williams

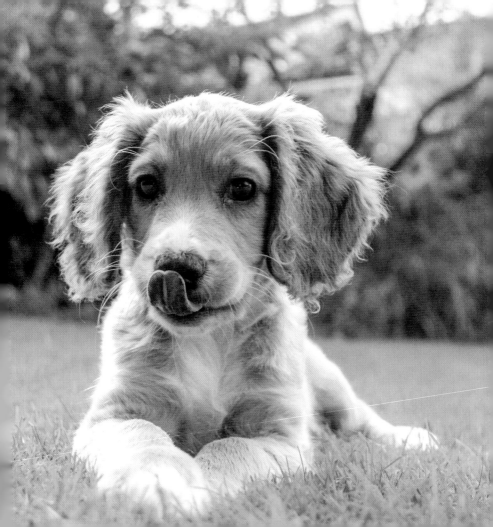

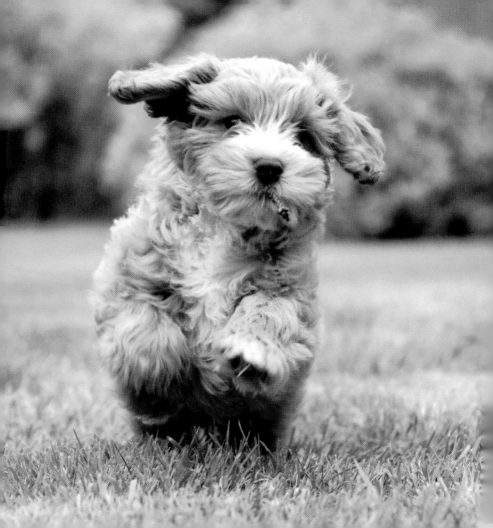

THIS IS WHAT

THEY CALL

❤ A SHAGGY ❤

DOG STORY!

# EVERYTHING I KNOW, I LEARNED FROM DOGS.

Nora Roberts

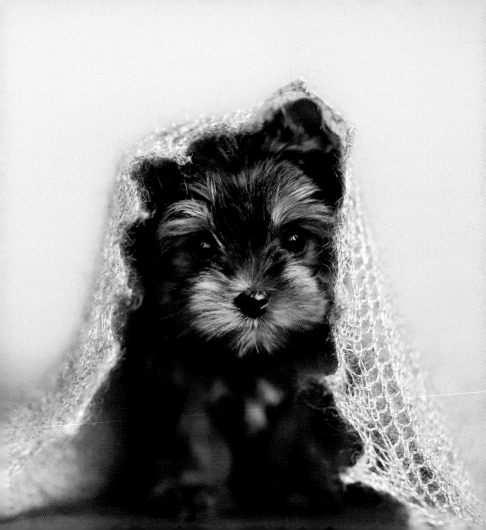

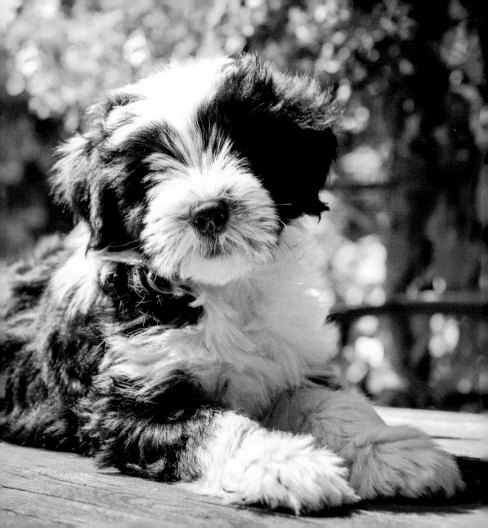

I'LL NEVER

♥ GIVE PUP ♥

ON YOU

A DOG IS THE ONLY THING ON EARTH THAT LOVES YOU MORE THAN HE LOVES HIMSELF.

Josh Billings

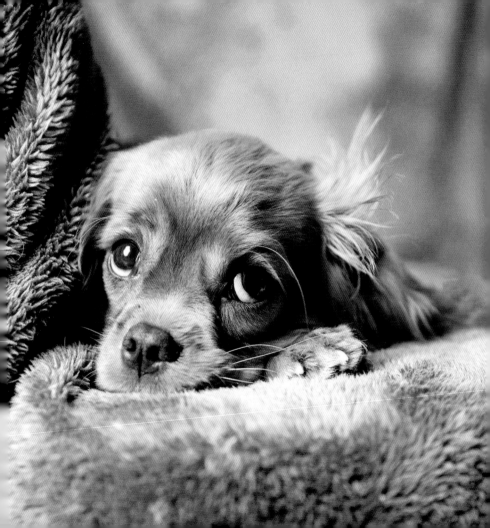

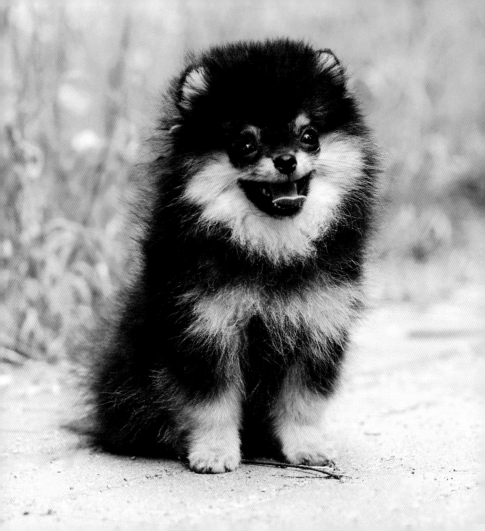

♥ I'M DESCENDED ♥

FROM WOLVES,

I'LL HAVE YOU KNOW

NO ONE APPRECIATES THE
VERY SPECIAL GENIUS OF YOUR
CONVERSATION AS THE DOG DOES.

Christopher Morley

# HOW DO WE GET THIS CUTE?
## ❤ LOTS OF ❤
# BEAUTY SLEEP!

# MY LITTLE DOG — A HEARTBEAT AT MY FEET.

Edith Wharton

If you're interested in finding out more about our books, find us on Facebook at **Summersdale Publishers** and follow us on Twitter at **@Summersdale**.

## www.summersdale.com

# IMAGE CREDITS